NEW YORK
Love Affair

Barbara E. Cohen

Foreword
by
Michael Cunningham
Pulitzer Prize Winner
The Hours

FIELDS
PUBLISHING

PO Box 564 • North Truro, MA 02652
508.487.5901 • www.charlesfields.net

New York Love Affair © 2010 by Barbara E. Cohen

First Edition

Cohen, Barbara E.

Cohen, New York Love Affair: photography and paintings by Barbara E. Cohen.—1st ed.

48 pages, 20.32 x 20.32 cm.

ISBN: 9780982319642

Library of Congress Cataloging-in-Publication Data

Library of Congress Control Number: 2009940041

1. New York City—Polaroid Paintings—Historical New York City Landmarks—New York City Scenes

Book and Cover Design by Charles and Gail Fields
Prepress Consultant Glenn Bassett
Production Assistant Kathryn Veatch

Fields Publishing—Award Winning Publisher of Fine Art and Photography Books
To order additional copies contact Independent Publishers Group at www.ipgbook.com 800.888.4741

Printed in South Korea

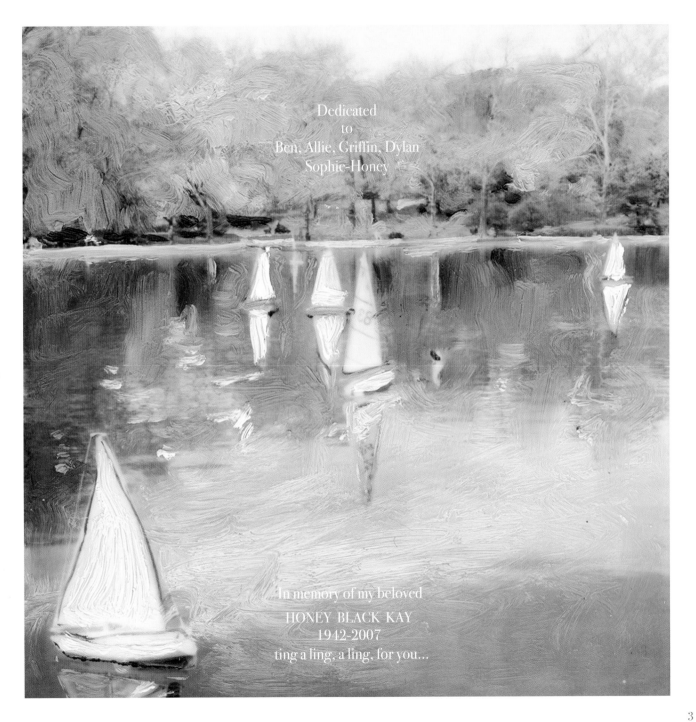

Dedicated
to
Ben, Allie, Griffin, Dylan
Sophie-Honey

In memory of my beloved

HONEY BLACK KAY
1942-2007
ting a ling, a ling, for you...

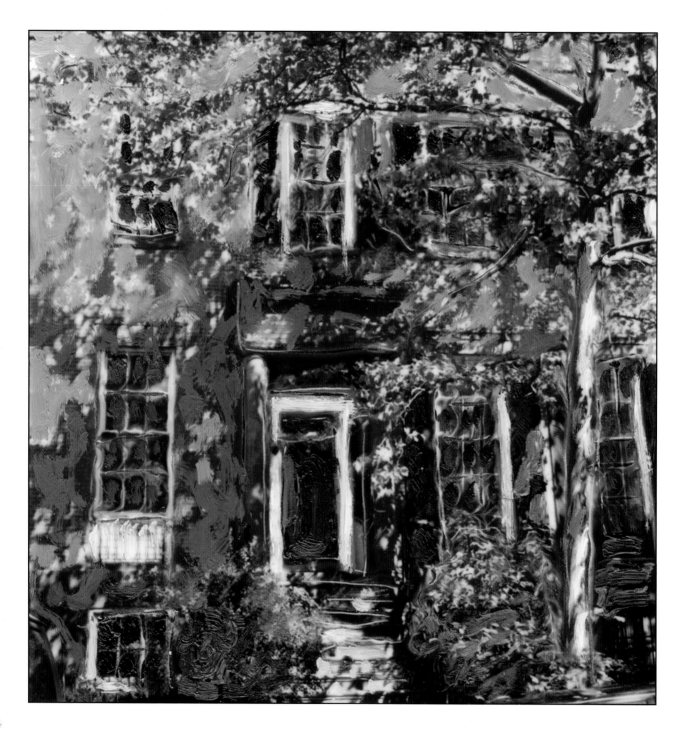

FOREWORD

Michael Cunningham

New York City tells at least a thousand and one stories about itself. We've heard most of them, over and over again. It's the City That Doesn't Sleep. It is, by its own reckoning, the Center of the Known Universe. It's brawny and brawling and brutally frank; it's the marketplace of the world; it's where a Wall Street titan may live next door to a rock star. And we know that in New York it's possible to make a living by calling yourself the Naked Cowboy, strolling around Times Square in your underwear with a guitar strung over your shoulders, and charging tourists to have their pictures taken with you. That fact alone sets it apart from any other city.

Of all these stories, however—all these proclivities and eccentricities and points of (sometimes debatable) pride—New York hardly ever talks anymore about its own beauty. It has not always been so. Remember Bernice Abbott's delirious black and white photographs? Remember Mondrian's "Broadway Boogie Woogie?" Remember the New York of Woody Allen's "Manhattan?"

The New York we love (and sometimes hate) today is a big sexy beast, but it is rarely if ever lauded as a beauty. In *New York Love Affair*, Barbara Cohen's ardent, earnest, unabashedly lovely depictions of the city go a long way toward reviving New York's sense of its own comeliness.

Right now, in the early part of the 21st century, it's a rare artist who doesn't shrink from beauty altogether or, at the very least, cloak it in irony. If most serious living artists balk at verdant land-scapes or laudatory portraits, you could count on one hand the number who are eager to wander anywhere close to a romantic, thriving New York.

Sometimes the bolder experiments are the ones that don't look like experiments at all. What Cohen offers with this collection of altered photographs is a more radical gesture than it may at first appear to be. She's insisting on New York City as a dowager queen, no longer young but all the more splendid for marching erect, in full regalia, into middle age. Cohen's New York is simultaneously her own and a revival of a past city—or, more accurately, a revival of a past perception of a city—that glows, that shimmers, that holds within itself dazzling brightnesses and deep, deep darks. Cohen's pictures, and the city they depict, are significant beauties.

—Michael Cunningham, author of Pulitzer Prize Winner *The Hours, A Home at the End of the World, Flesh and Blood* and *Specimen Days.*

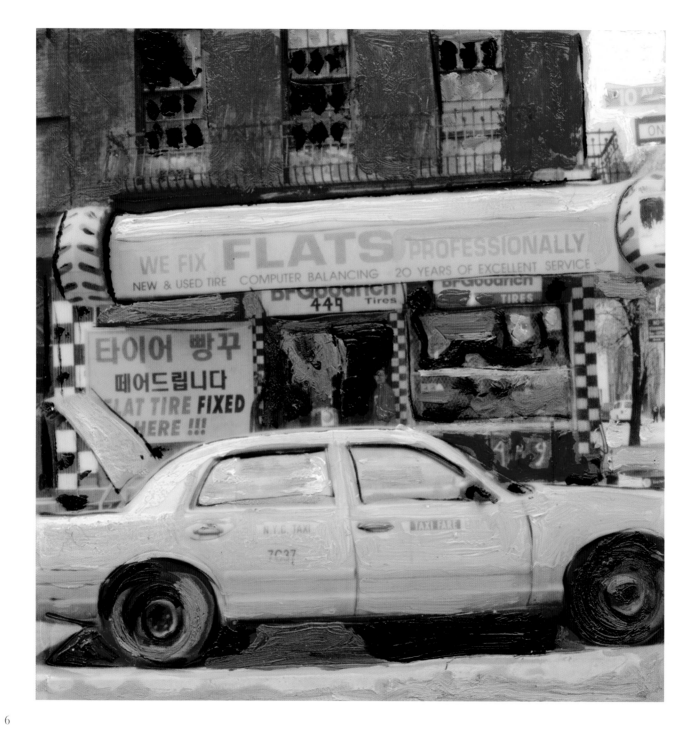

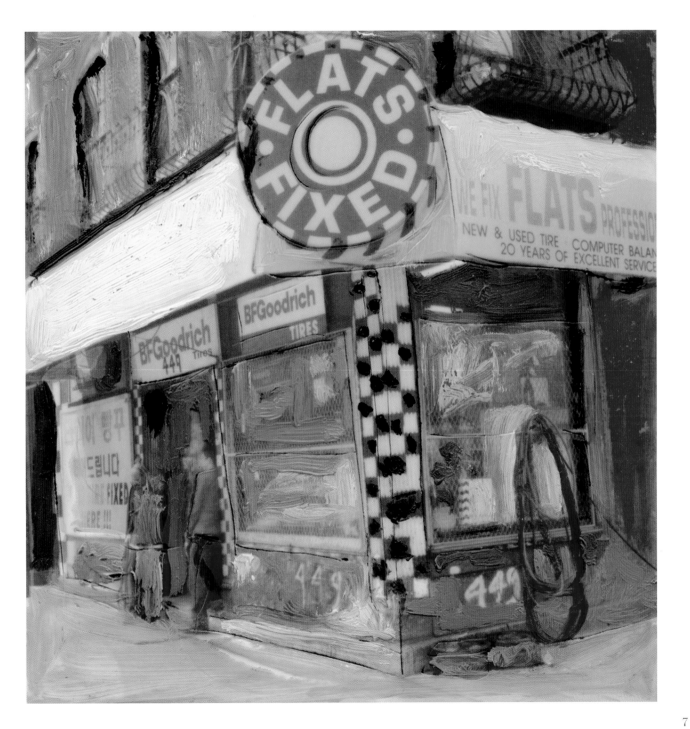

7

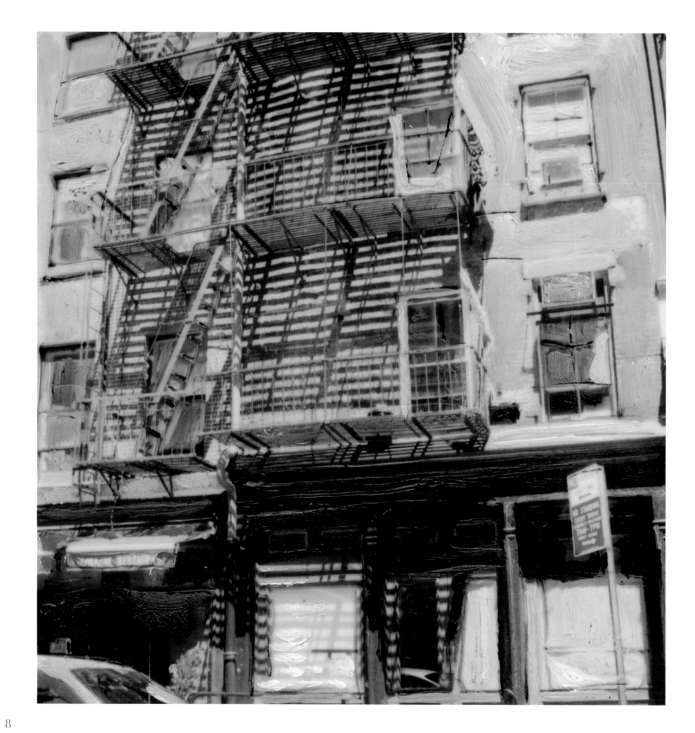

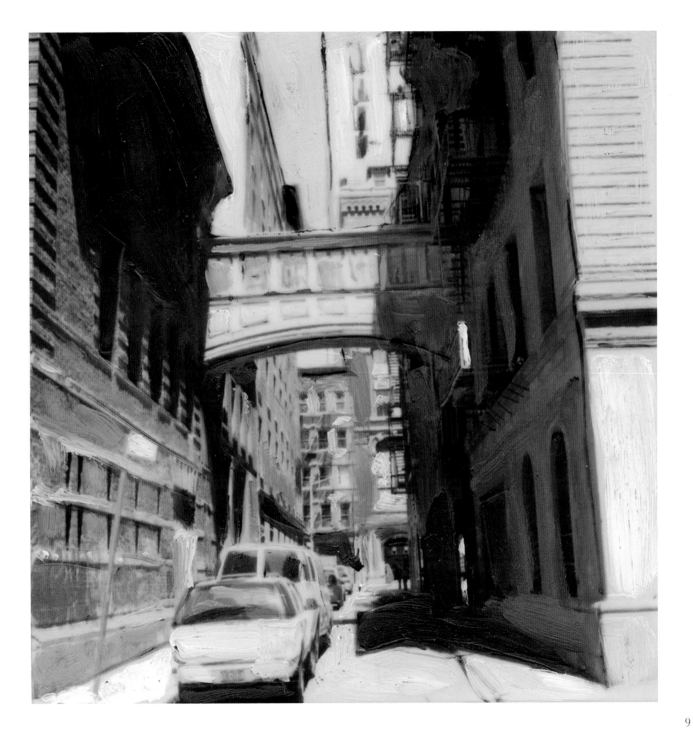

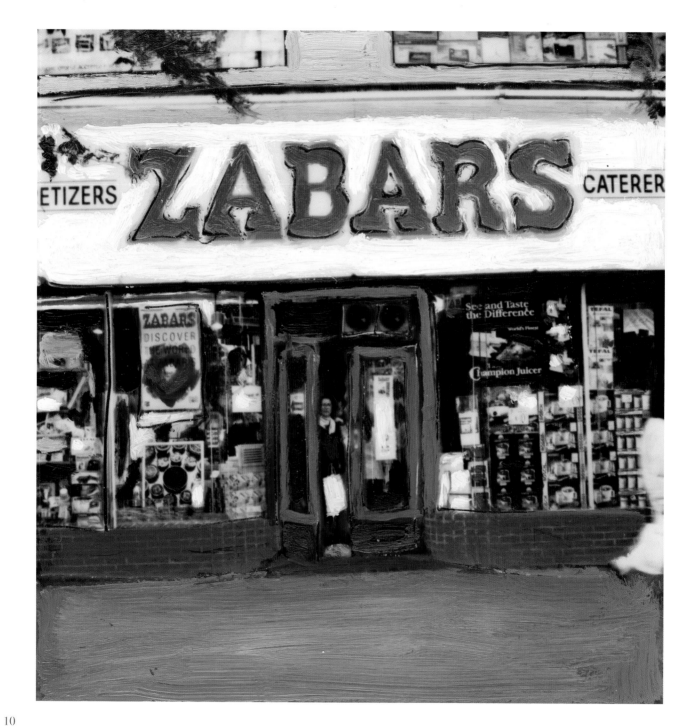

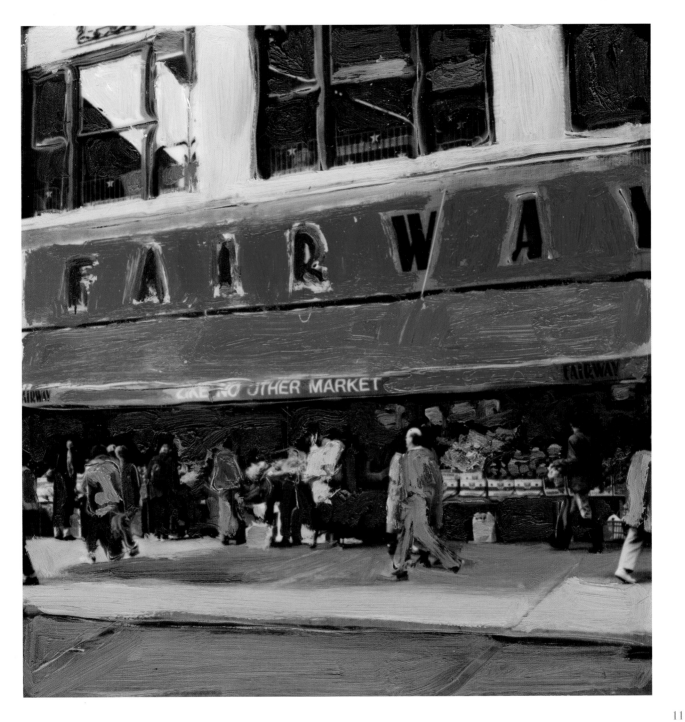

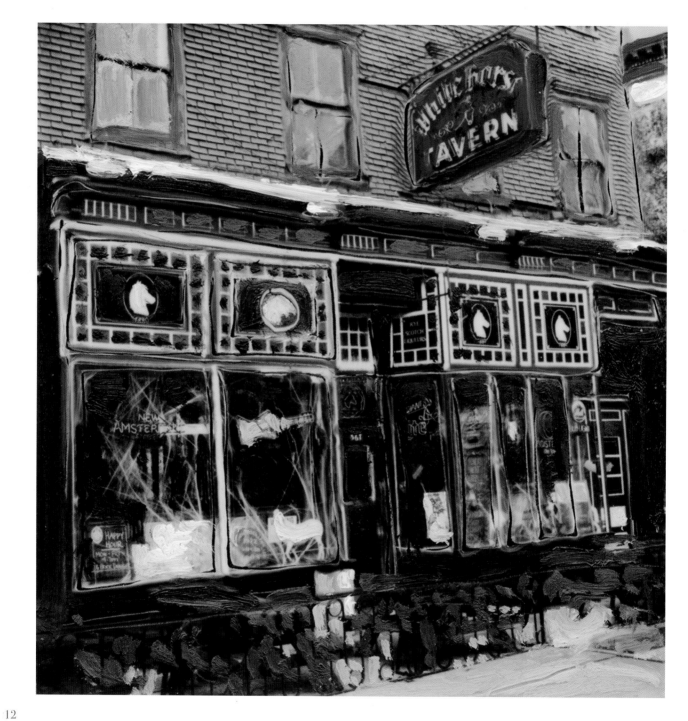

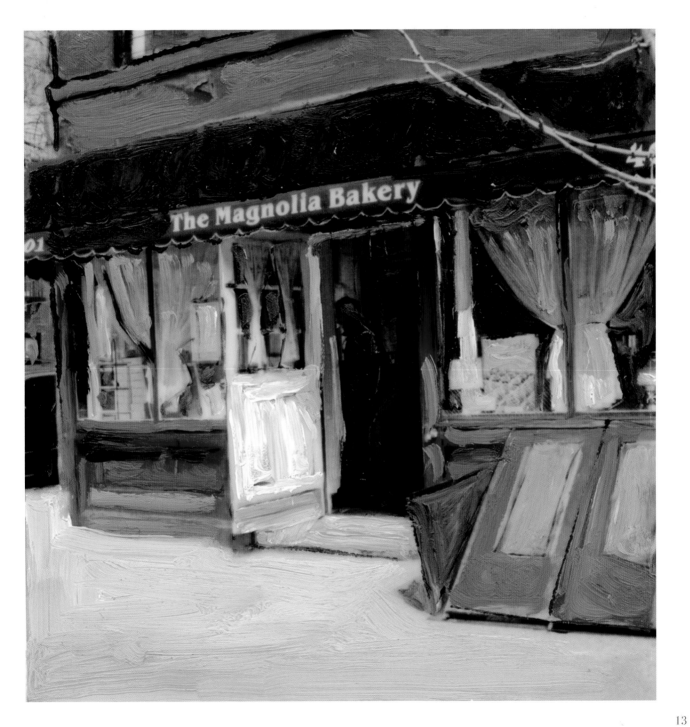

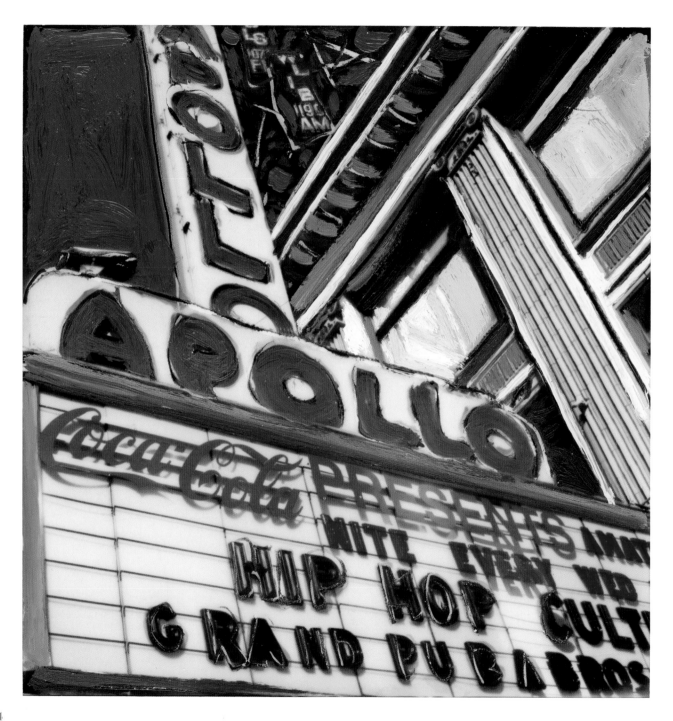

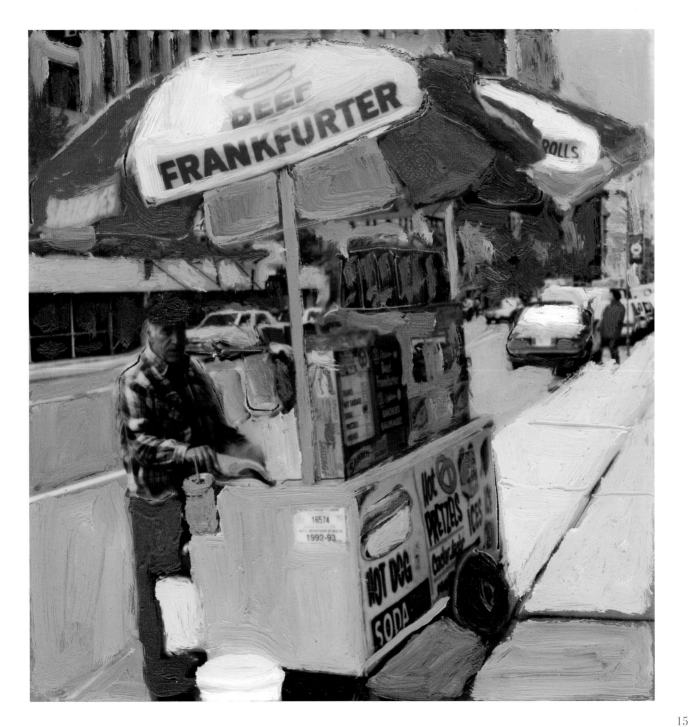

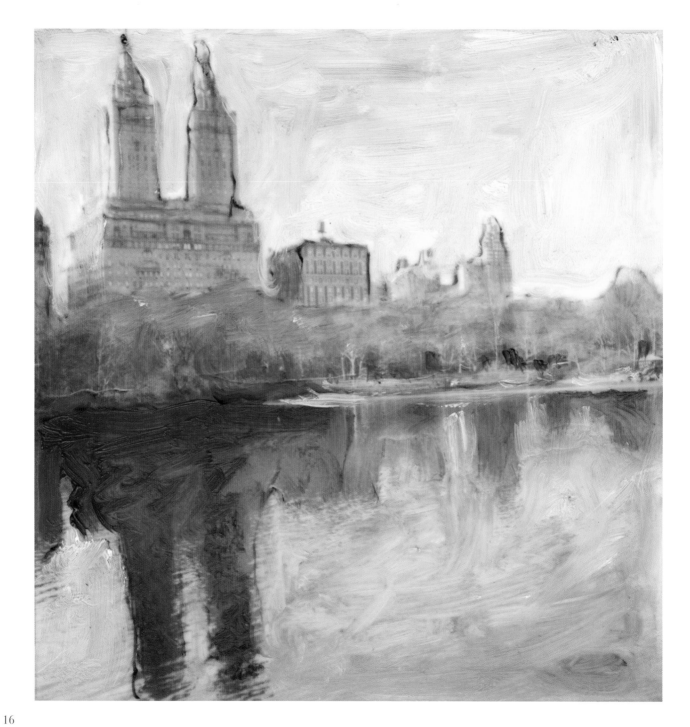

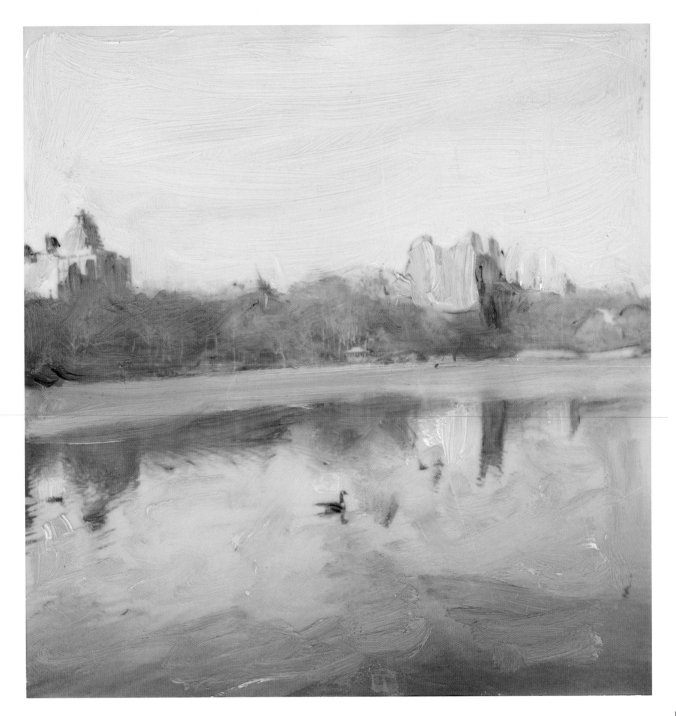

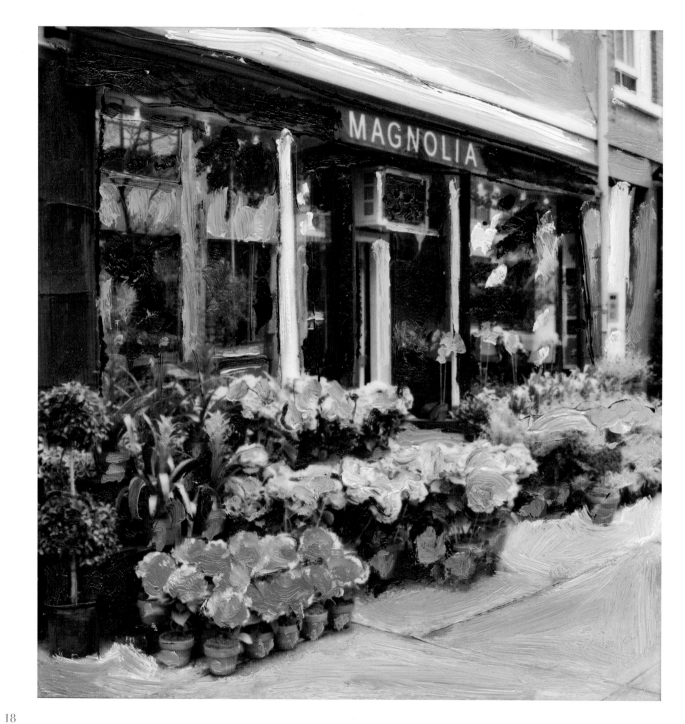

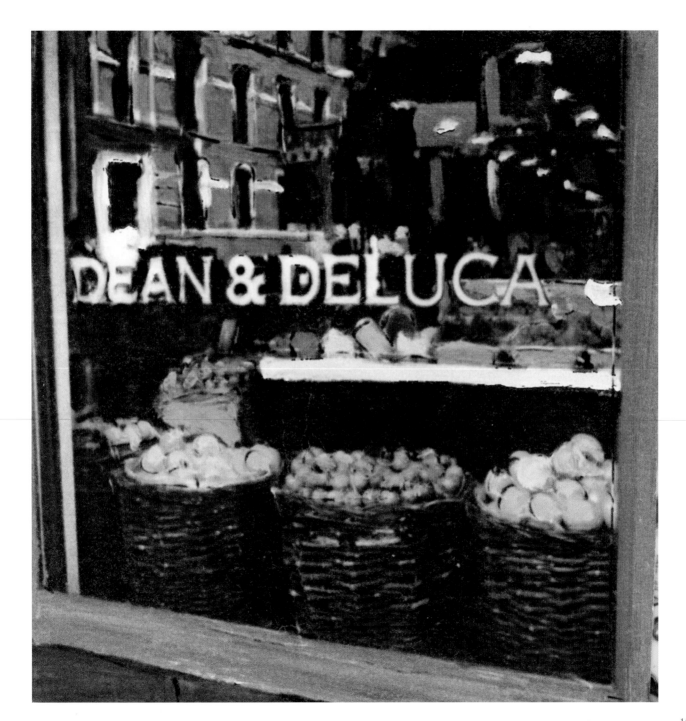

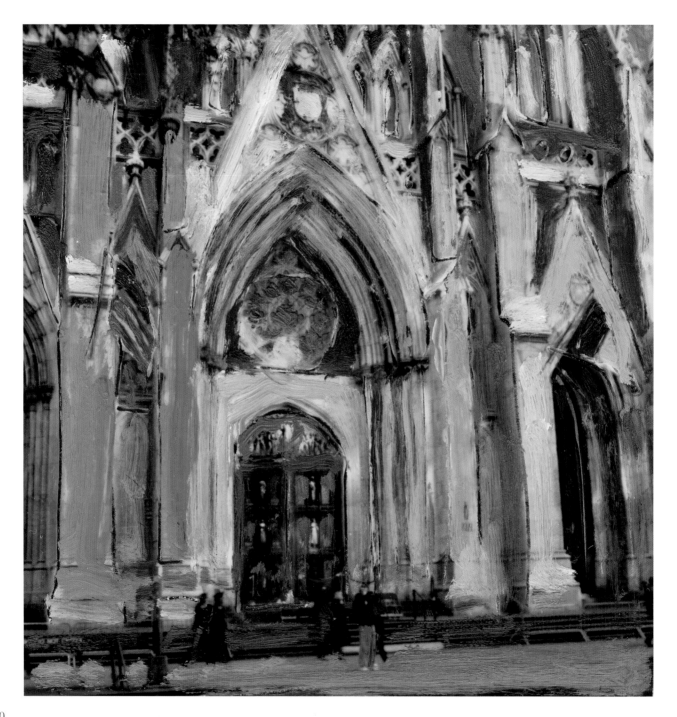

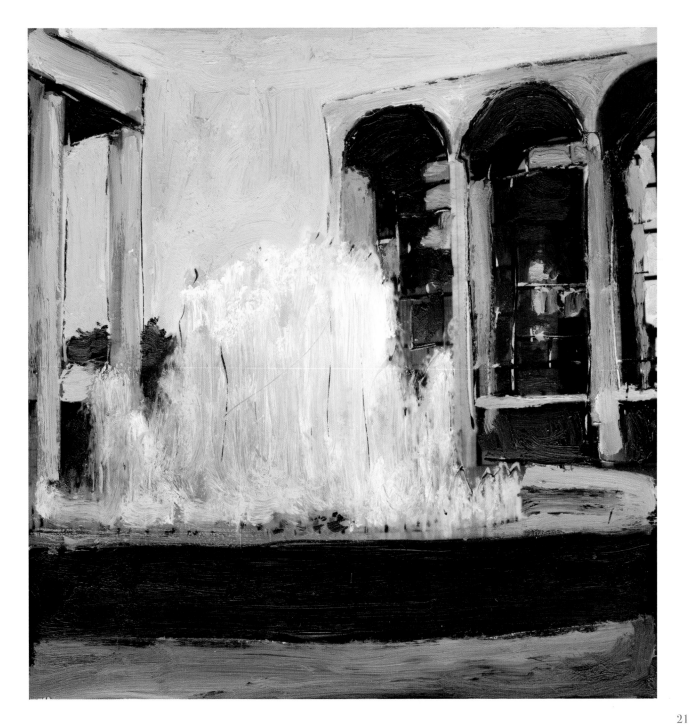

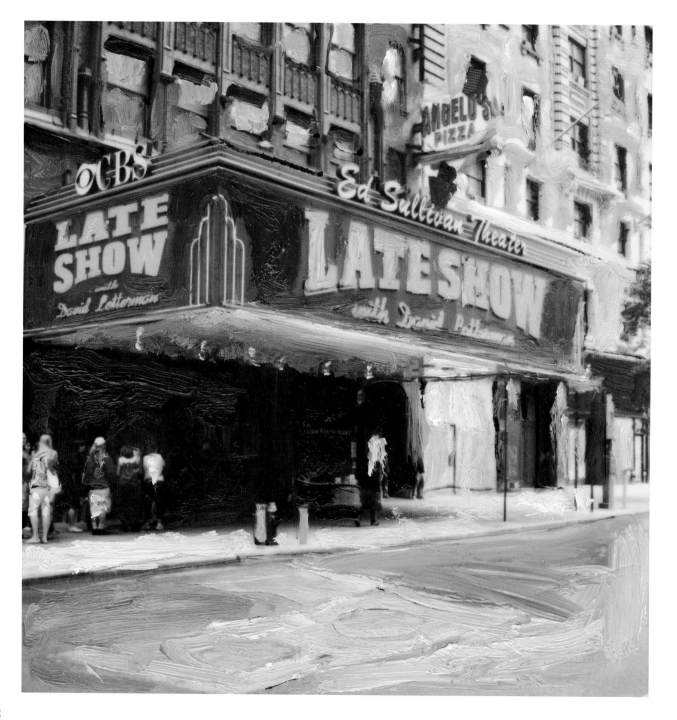

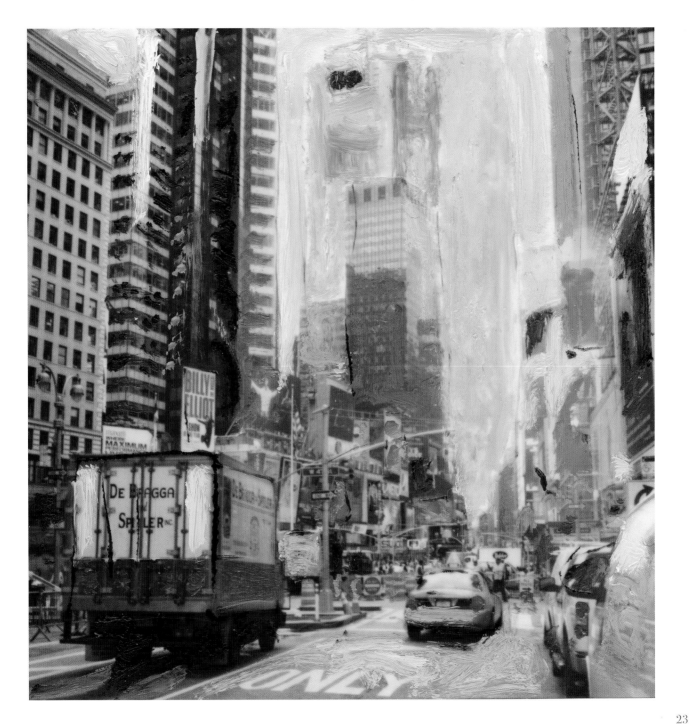

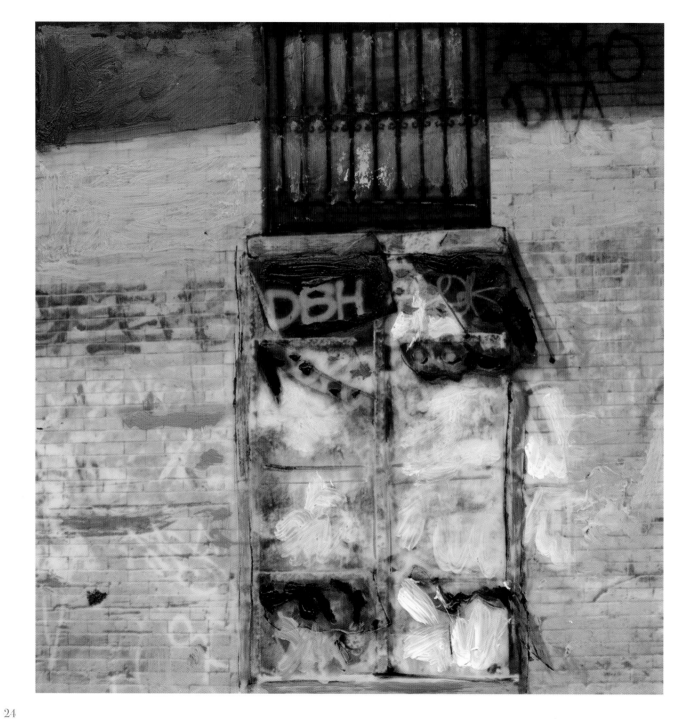

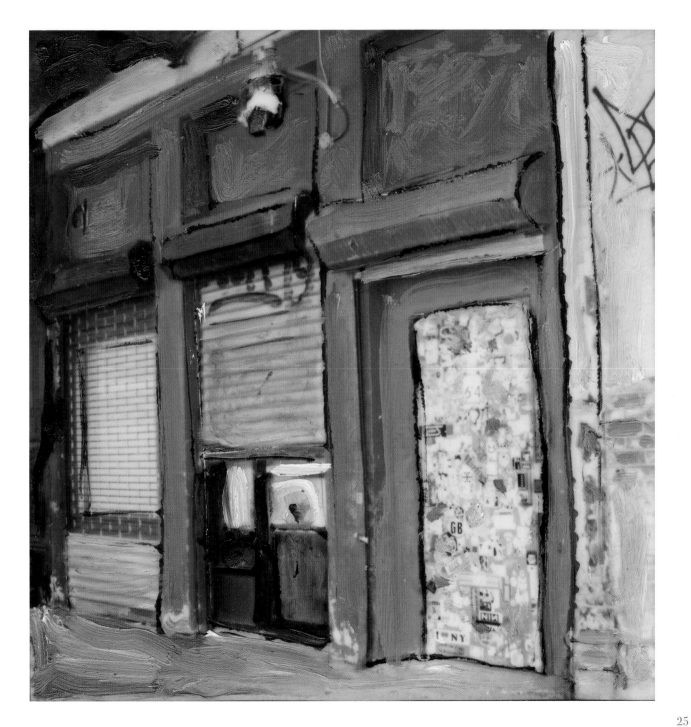

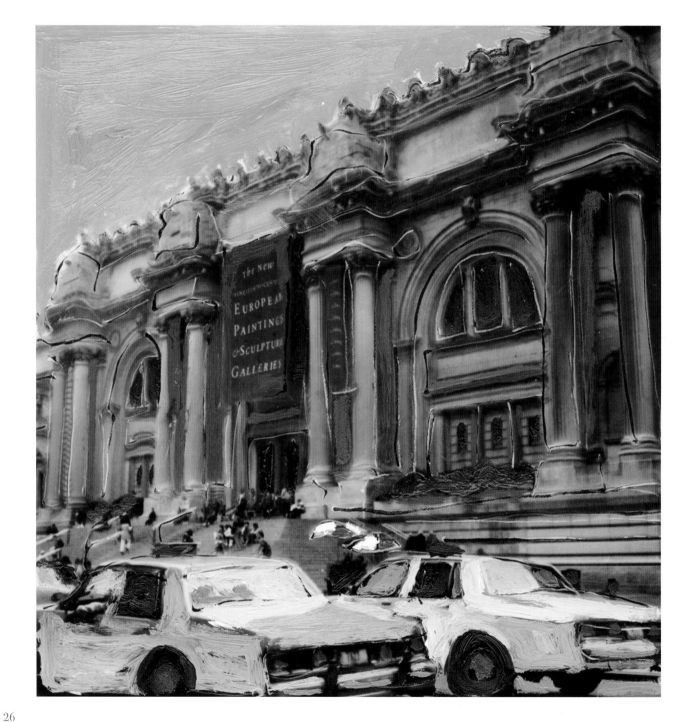

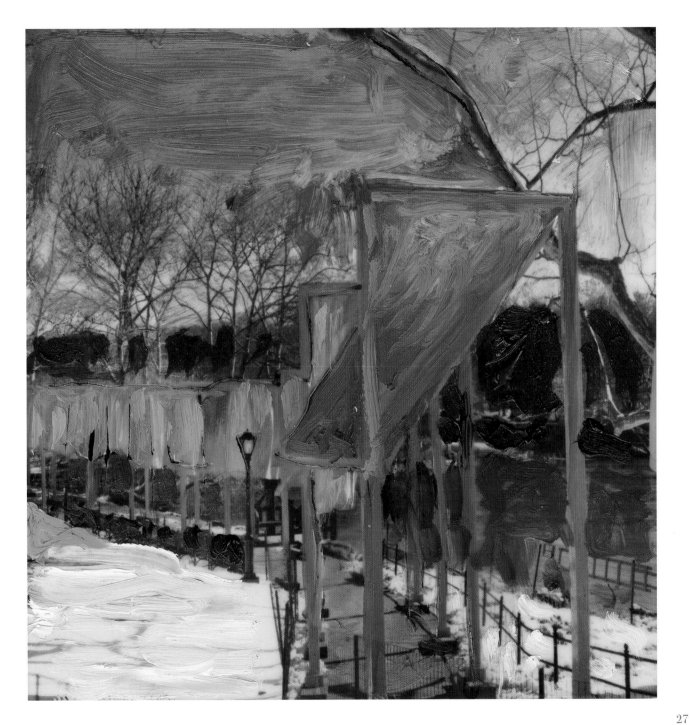

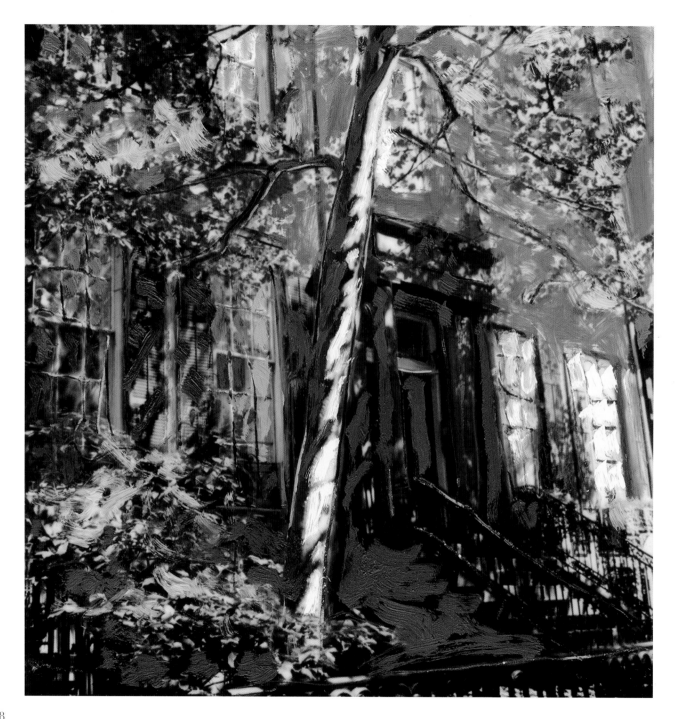

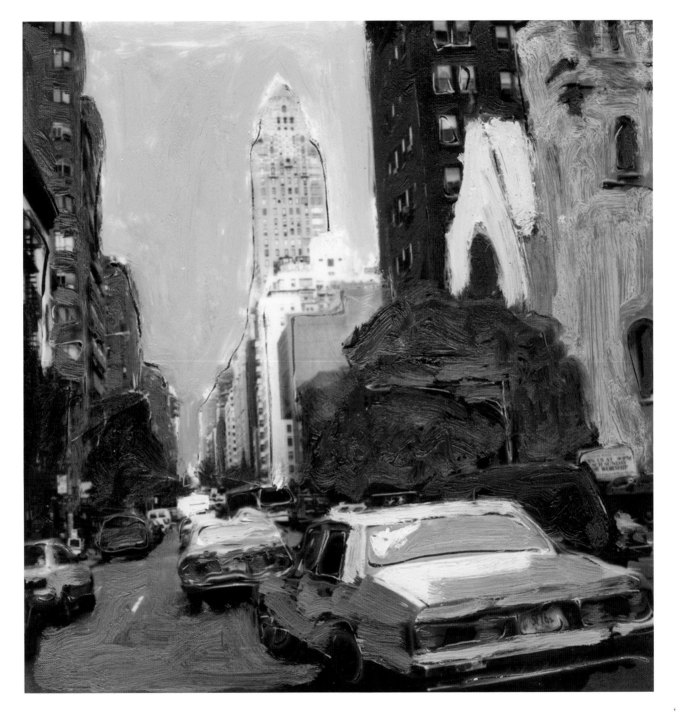

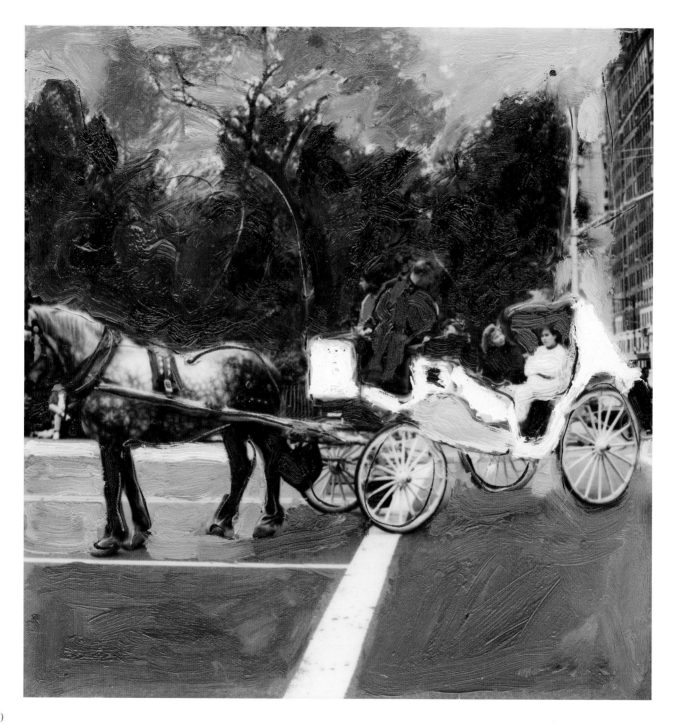

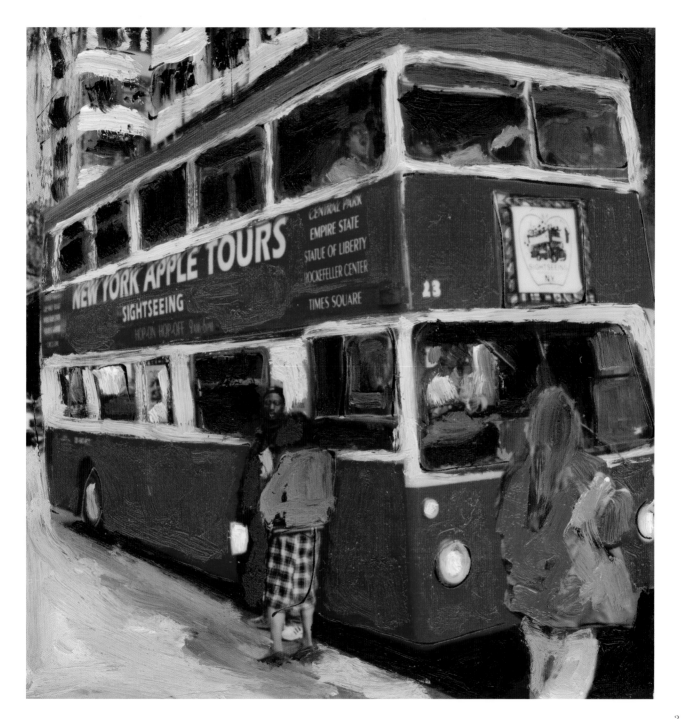

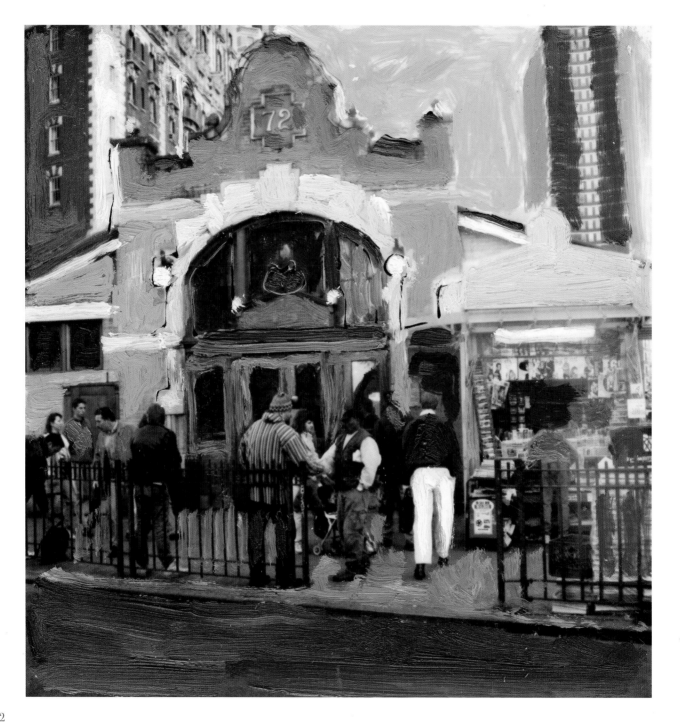

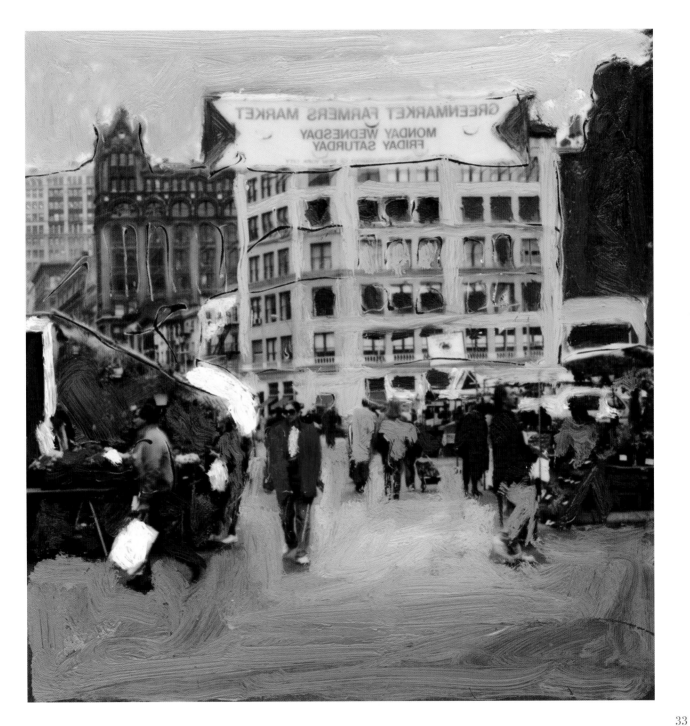

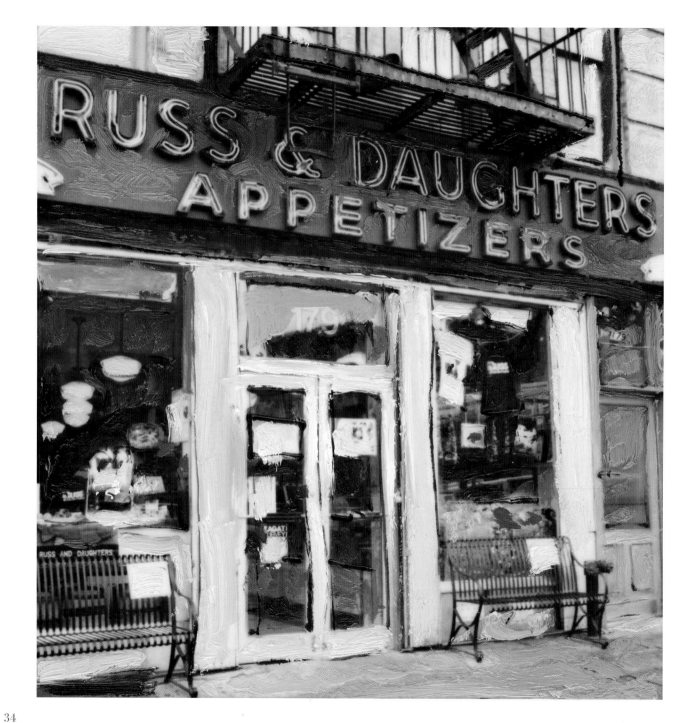

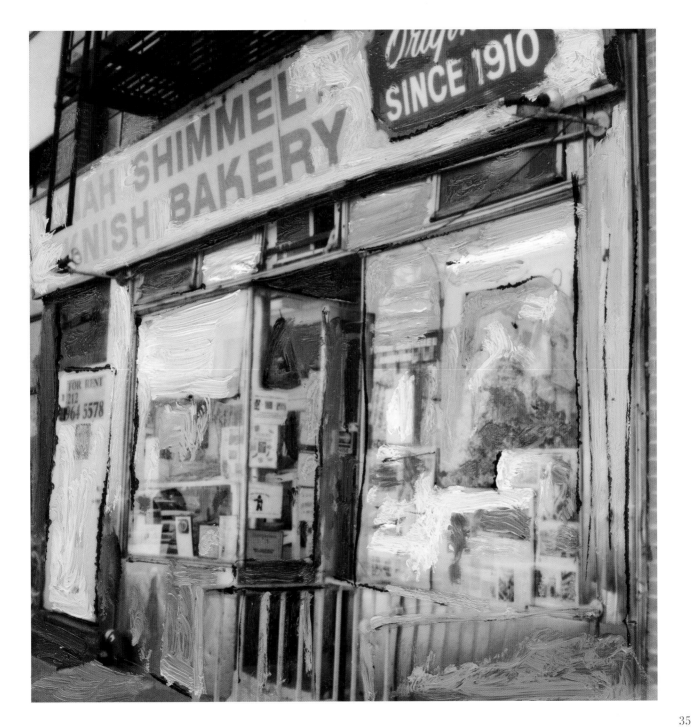

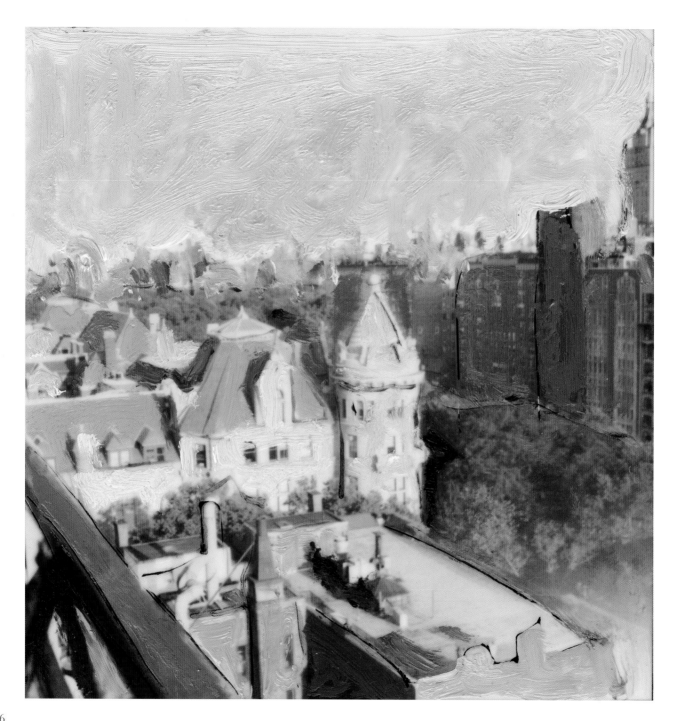

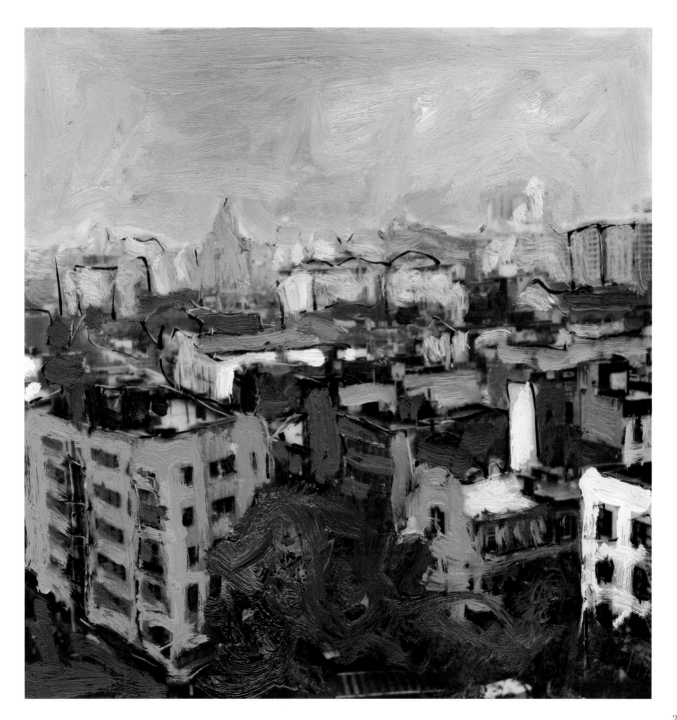

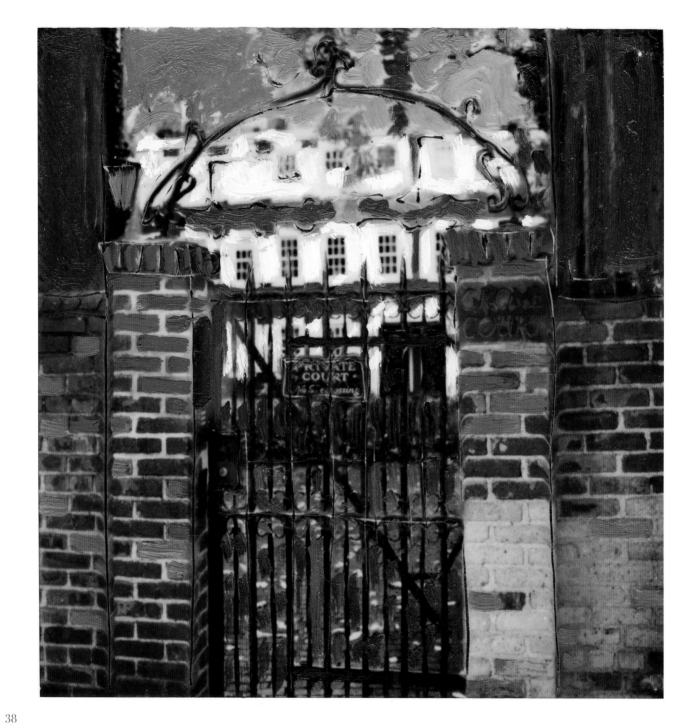

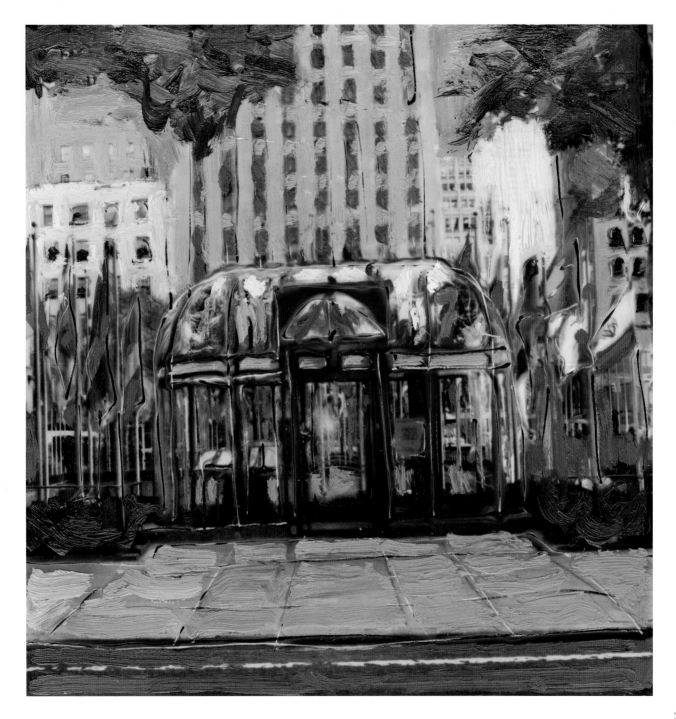

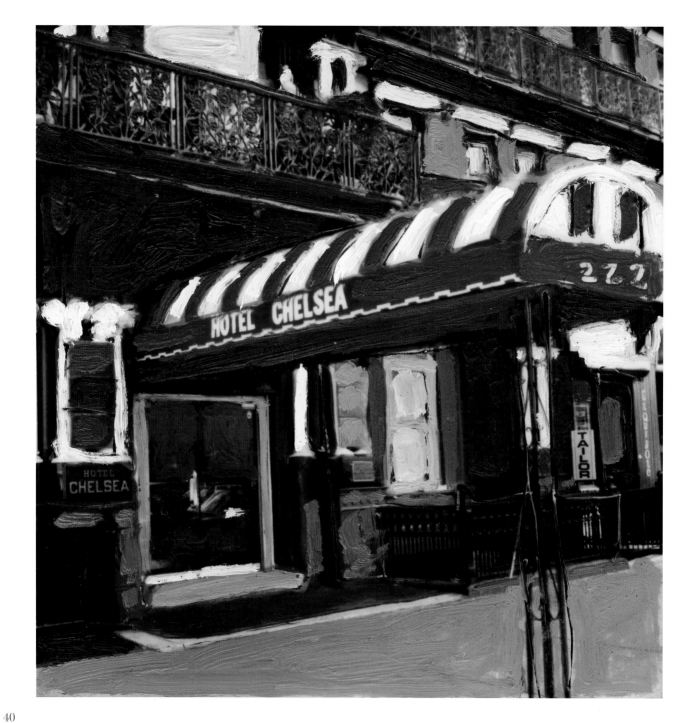

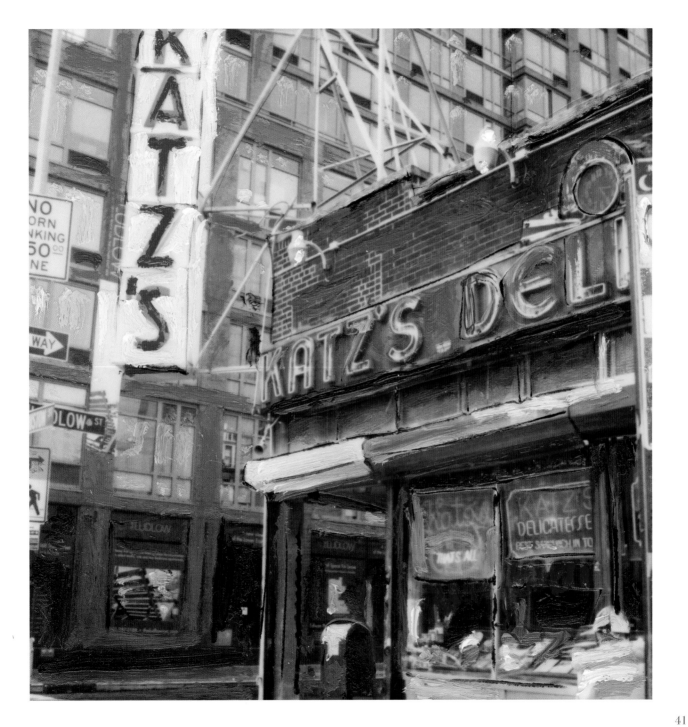

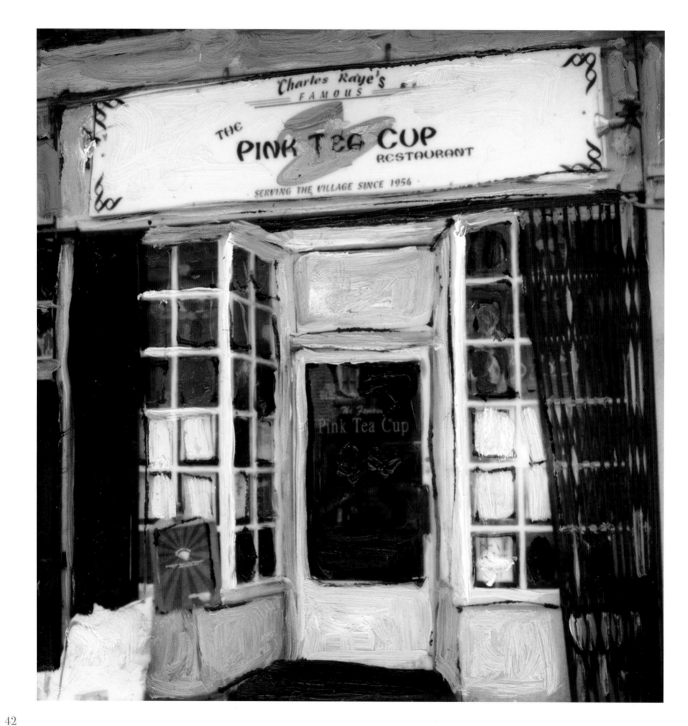

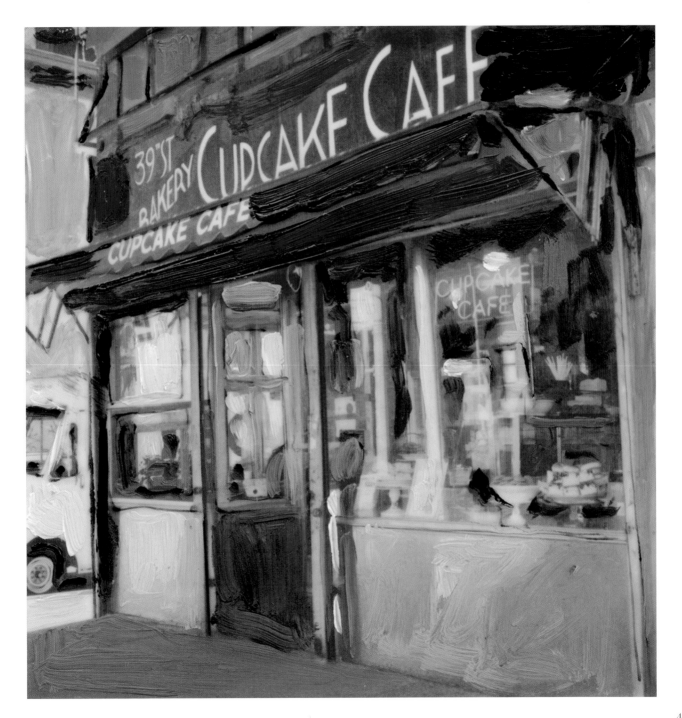

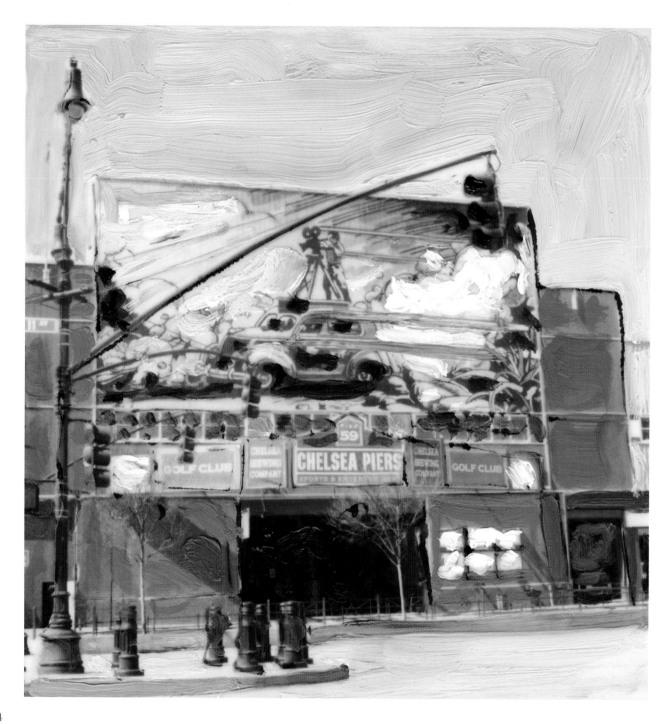

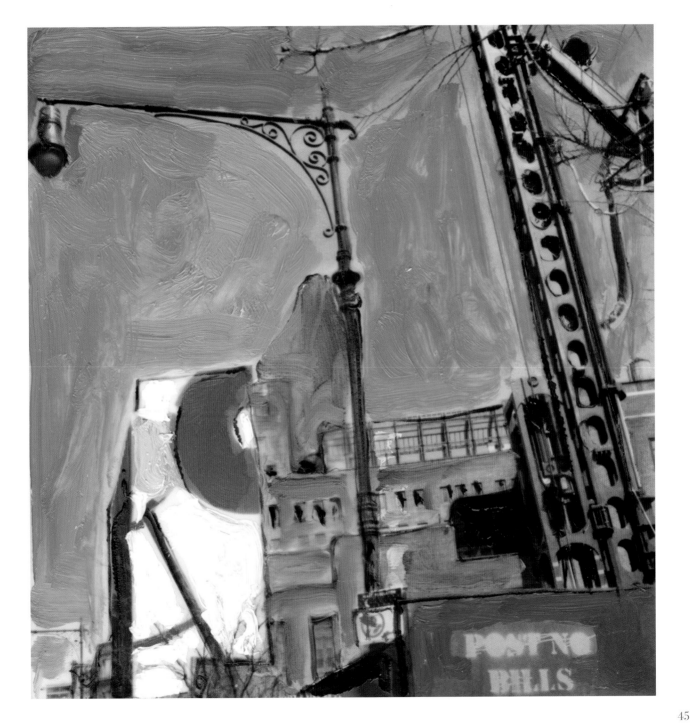

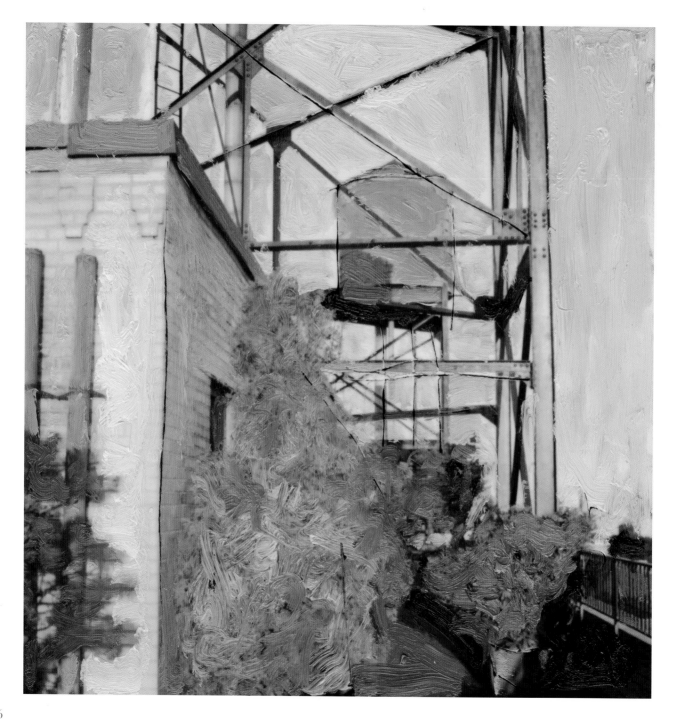

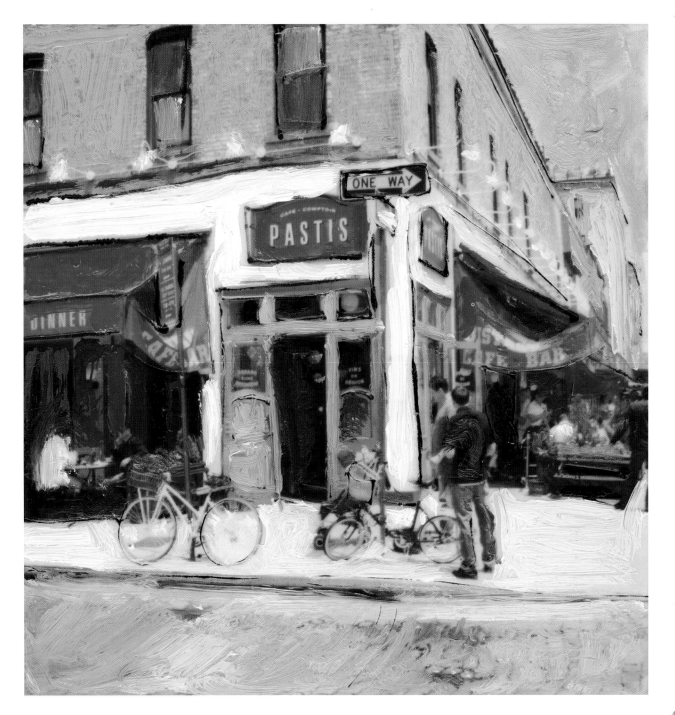

INDEX